Metal Craftsmanship in Early Ireland

Michael Ryan

Country House, Dublin

Published in 1993 by
Town House and Country House
42 Morehampton Road
Donnybrook
Dublin 4
Ireland

British Library Cataloguing in Publication Data. A catalogue record for this book is available from the British Library.

ISBN: 0-946172-37-4

Illustration acknowledgements
The Ulster Museum, photo 3; Michael Ryan, plate 3 and photos 2 and 6; The National Museum of Scotland, plate 9; The Hunt Museum, Limerick, plate 17 and photo 8. All the remaining photographs are copyright of The National Museum of Ireland.

Managing editor: Treasa Coady
Text editor: Séamas Ó Brógáin
Design: Bill Murphy
Origination: The Kulor Centre
Printed in Ireland by Criterion Press, Dublin

CONTENTS

FINE METALWORK, manuscript painting and sculpture attained a perfection in early medieval Ireland (*c.* AD 450–1200) that has lost none of its power to delight and surprise us. All three arts are closely interlinked in their decoration, symbolism, and use of colour. It seems that scribes and sculptors sometimes had specific metalwork models in mind when they were at work.

The metalworker developed a style during the fifth and sixth centuries that drew on prehistoric Celtic traditions of bronzeworking and added to them new ideas borrowed from late Roman Britain. During the later sixth and seventh centuries, influences from Christian art and from that of the Anglo-Saxons and perhaps the Franks were adopted to form a new art that was patronised by the church.

WORKSHOPS

Slag — the characteristic refuse of workshops — as well as fragments of clay moulds, furnaces, and even unfinished pieces, have been discovered on both secular and monastic sites ranging from the fifth or sixth to the ninth century. At the ring-fort of Garranes, Co Cork, bronzesmiths were manufacturing brooches and enriching their work with enamel and millefiori glass in the sixth and seventh centuries. A seventh-century workshop was excavated at the royal site of Clogher, Co Tyrone, where evidence of brooch-making was discovered. The residents of both places engaged in some form of long-distance trade, as fragments of imported Mediterranean pottery and, at Clogher, material from western France also were found. In the eighth century a goldsmith was at work at the fort of Garryduff, Co Cork.

The crannóg or lake-dwelling of Moynagh Lough, Co Meath, revealed two phases of metalworking activity, the first in the late seventh and early eighth centuries and the second before AD 748. Gold filigree was made, while amber and enamelling added colour to the objects produced. Many fragments of clay moulds and crucibles, as well as a furnace and substantial quantities of raked-out ash, indicate considerable production. Nevertheless, as at Garryduff, the occupants of the crannóg supported themselves by farming. Although some of them might have been specialist craftworkers, this was not enough to provide a livelihood. The artisan who worked on the royal crannóg

5

of Lagore, Co Meath, in the eighth or ninth century was presumably employed by the king who resided there. Metalworkers, including some engaged in ambitious design, were among those who lived, probably seasonally, on the sandhills of Dooey, Co Donegal, in the sixth century.

At Cathedral Hill, Armagh, moulds and other material were found, suggesting the practice of high-quality metalworking on the monastic site. At Scotch Street, also within the ancient monastery, debris of glass, amber, lignite and metal was discovered, but the site of the craftworking was not found. Evidence for metalworking has been uncovered at the monastic sites of Movilla, Co Down, and Clonmacnoise, Co Offaly.

Excavations at Nendrum, Co Down, revealed substantial evidence of fine metalworking in the form of crucibles and their stone holders, dating probably from the eighth to the tenth century, when the monastery was burnt by the Vikings. The excavation of ecclesiastical sites is still limited, and we are not likely to discover much about industrial activities in the sacred cores of the monasteries, where most of the research has so far been concentrated.

There is little direct evidence for rural workshops in the period after AD 800. We can only infer that they existed and produced significant work despite the Viking onslaught. Important relics were enshrined in the ninth and tenth centuries: the prominent king Flann Sinna, who died in AD 916, commissioned a shrine for the Book of Durrow, and his gift was matched by his son Donnchadh for the Book of Armagh in 938. Neither survives.

Inscriptions on reliquaries provide insights into the organisation of craftworking. The shrine for the Cathach of St Colm Cille was made at the monastery of Kells in the late eleventh century by Sitric, son of Mac Aedha. The Shrine of the

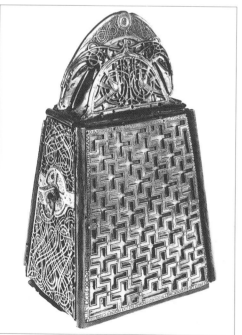

Photo 1 *The Shrine of St Patrick's Bell, c. AD 1100. The inscription on the back records that the reliquary was made by a master craftsman, Cú Duilig, and his sons.*

6

Stowe Missal was made by Donncha Ó Taccáin in the monastery of Cluain (Clonmacnoise). Around the year 1100, Cú Duilig Ó hInmainen and his sons made the Shrine of St Patrick's Bell under the patronage of King Domhnall Ó Lochlann (Photo 1). This is interesting confirmation of the hereditary practice of a craft. In exceptional circumstances, where male succession failed, the Breton Laws allowed women to carry on the paternal profession. The laws also provided in general terms for craft training. Fine metalworkers enjoyed a high but not a noble status: Moynagh Lough and Garryduff seem to confirm this, as both were substantial homesteads, although whether the occupants were tenants or owners we do not know.

Because assembly codes employing letters were used on some objects, such as the Derrynaflan Paten (Pl 13), we may guess that some metalworkers were literate and therefore probably clerics; but monastic communities were large and had many secular dependants, so their craftsmen could also have been lay.

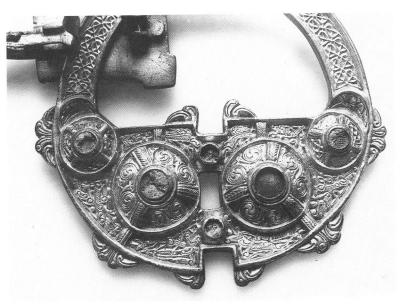

Photo 2 *Annular brooch of debased silver with cast, not engraved, ornament of birds, beasts, spiral scrolls, and interlace, eighth to ninth century AD. The diameter of the ring is 101.5 mm. Called the Londesborough Brooch after a collector who owned it in the nineteenth century, its find place is unknown. It is now in the British Museum.*

7

TECHNIQUES AND ORNAMENTATION

Casting, usually in bronze but also occasionally in silver (Photo 2), was commonly used to make objects. Two-piece clay moulds were normally employed, and lead models that were sometimes used as the forms for shaping the moulds have been found. In general, small objects such as brooches or decorative mounts were cast in the moulds; for larger and more complicated castings the 'lost wax' method was employed. A model in wax, including a pouring funnel, was prepared and dipped into a suspension of fine clay several times to build up layers of coating. This was then enclosed in a mass of wet clay, allowed to dry, and then baked hard so that the wax inside melted and formed a hollow into which molten metal could be poured. To remove the cast object the mould was broken. The skill of the ancient craftworkers is shown by the quality of cast ornament on the stem of the Ardagh Chalice (eighth century) (Pl 12; Photo 14*b*) and on the Tara Brooch (*c.* 700). Cast decoration seems to have been preferred to engraving in many workshops.

But *engraving* was skilfully employed (Photo 14*a*). One method required covering a bronze plate with a layer of tin and cutting through it to reveal the contrasting colour underneath. The finest examples of this method are to be seen on the Donore plates, probably door furniture, from Co Meath (*c.* 700) (Pl 1) and on the Clonmore, Co Armagh, (Photo 3) and Bobbio shrines (seventh century). Another way of producing a two-coloured effect was to overlay a sheet of metal with a decorative openwork plate. Examples occur on the eighth-century book-shrine from Lough Kinale, Co Longford (Photo 15), and a variant on twelfth-century work such as the Cross of Cong (Pl 20) and the Shrine of St Patrick's Bell.

Die-stamping was used to create copies of patterns. Thin sheets of silver, gold or copper were stamped in dies that had the pattern cast or engraved in reverse within. Many die-stamped panels, such as those on the eighth-century Moylough Belt-shrine (Pl 2), are small, but the gold foils on the side of the Derrynaflan Paten are so evenly struck throughout their length that a mechanical press may have been used to produce them.

Silver and copper were sometimes combined in interesting ways. On both the Ardagh Chalice and the Derrynaflan Paten a knitted wire mesh of both

8

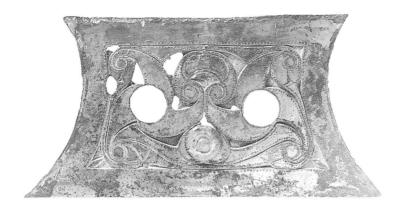

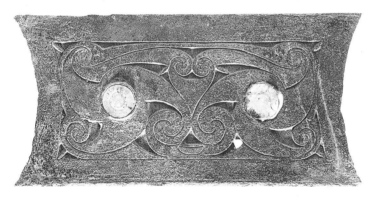

Photo 3 *Two plates of a house-shaped shrine found in spoil from the River Blackwater at Clonmore, Co Armagh. Made of engraved tinned bronze, the plates formed a little casket for the protection of a relic. Date: mid-seventh century AD.*

metals is employed. Thick plaited silver and copper or bronze wire was hammered into grooves on some twelfth-century pieces to create a herringbone pattern. A version of this was found on a fragment set into a lead weight in a ninth-century grave in the Viking-age cemetery of Islandbridge, Dublin (Photo 17). On two eighth-century shrines, the Emly and Abbadia San Salvatore (Pl 3) reliquaries, a white metal is inlaid directly into grooves in their wooden boxes in complex ornamental networks of crosses.

Bronze and silver were often gilded. Two methods of *gilding* were known: covering a surface with a sheet of gold leaf, and fire-gilding. In the first — which was rarely used — the leaf is held in place mechanically. In fire-

9

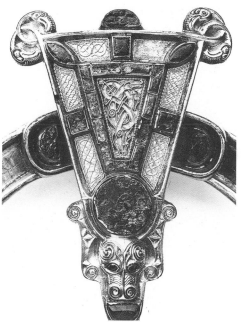

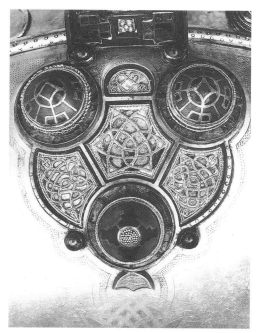

Photo 4 *Gold filigree and cast ornament on the head of the pin of the Tara Brooch, late seventh to early eighth century AD. The filigree in the central panel depicts a quadruped in a figure-of-eight knot. It is formed of a ribbon on edge capped with beaded wire. Tiny nicks in the walls of the panels containing the filigree are 'stitches' — spurs of metal turned out with an engraving tool to hold the panel in place.*

Photo 5 *Gold filigree on the escutcheon plate of a handle of the Ardagh Chalice, eighth century AD. The patterns were executed on foil, and the wires were soldered to the ridges forming the design. The background was cut away and the whole laid on a second foil sheet. Beaded and twisted wires are used. The stud at the bottom is enriched with granules of gold.*

gilding, a small quantity of gold is dissolved in mercury and the amalgam is applied to the surface. It is then heated, which causes the mercury to evaporate, leaving a thin layer of gold behind. Strips and sheets of silver foil were often crimped in cast grooves or ornamental panels in objects of eleventh- and twelfth-century date.

Many of the finest pieces are decorated with *gold filigree* — patterns made of soldered gold wires (Pl 4; Photo 4). In Ireland and Scotland during this period, filigree is never applied directly (Pl 9). Instead the ornament is formed on small foil panels, which are then fixed in place, usually in recesses cast for the purpose. Sometimes the filigree panels are held by frames; occasionally they are riveted in place.

10 Great variety was achieved in filigree by a number of technical tricks. The

design was sometimes stamped or traced in repoussé on the foil, and the wires were then soldered to ridges on the gold to give a three-dimensional effect (Photo 5). The background to the design might be cut away and an additional gold, or sometimes silver, backing-plate inserted.

The filigree wire was made of long, narrow bars of gold, twisted and rolled to produce a rounded cross-section. These were used plain or were beaded and combined together or with ribbons of gold. The expertise of the goldsmiths was exceptional. On the best pieces the soldered joint was always created precisely where it was needed, so that no molten metal flooded the patterns. Silver filigree is not known before the Viking Age, when it appears on a number of brooches.

In *granulation*, small spherical beads of gold were created in a number of ways, for example by heating pieces of gold on a bed of charcoal by means of a blow-pipe carrying hot gases from a furnace, so that they melted and danced like water droplets on a hot stove. Granules were used mostly for emphasising details such as the eyes and joints of animals and the centres of spirals and scroll-endings. The Hunterston Brooch from Ayrshire, Scotland (similar to the Tara Brooch), uses granulation as infill for animal patterns, something that is not known on Irish objects before the Viking Age.

The use of metal plating and filigree ensured a colourful style, but the polychrome effect was greatly enhanced by *enamelling*. Since Iron Age times, Irish smiths had used this glass-like material in inlays to embellish their work. Red enamel was favoured, but by the end of the sixth century blue, green and yellow enamels also became available and were widely used. Enamel in powdered form was applied in narrow grooves or broad fields engraved or cast into the surface of the metal, and the piece was heated so that it fused in place. This technique, known as champlevé, was the method preferred by Irish

Photo 6 *Reverse of a brooch from Co Westmeath, eighth century AD, now in the British Museum. The animal pattern is enamelled, the pattern being laid out in lines of reserved bronze.*

11

craftworkers until the twelfth century (Photo 6). The cloisonné technique, whereby enamel is used to fill compartments or cells built up on the surface of the metal, only appears in Ireland on two twelfth-century objects.

One embellishment greatly appreciated in Ireland was *millefiori glass.*

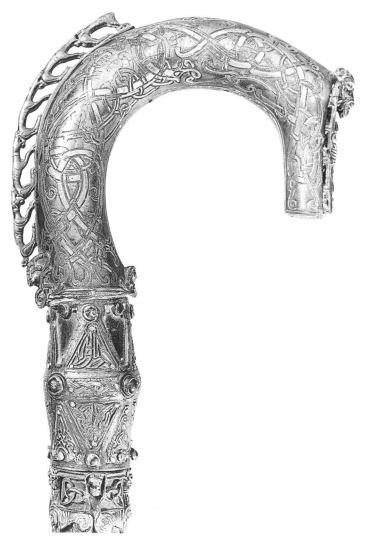

Photo 7 *The crook of the crosier of the Abbots of Clonmacnoise, early twelfth century AD. The complex animal interlacing is silver and niello inlaid into the copper plate.*

Thin glass rods of different colours were placed together in bundles so that they show a decorative pattern in cross-section; they were then fused together, drawn out, cut into platelets and set. Chequerboard and sunburst patterns are common. Millefiori first appears on Irish work in the sixth century (Pl 5) and remained in fashion until the eighth century. It reappears in a modified form on the twelfth-century Lismore Crosier (Photo 20*a*).

Niello is a black compound made of sulphides of silver or copper fused to metal at a low temperature. It was used by the Romans to highlight decorative features or to fill in inscriptions on silver, and is thought to have been unknown in Ireland before Viking times. There are a couple of examples in seventh-century contexts. In metalwork influenced by Viking ornament in the eleventh and twelfth centuries it was elegantly combined with inlays of silver strip or wire. Good examples can be seen on the shrine of the Cathach and on the crosier of the Abbots of Clonmacnoise (Photo 7).

Precious stones are rare on early Irish metalwork. Amber, which is not a hard material and can be cut and polished easily, was favoured. It can also be softened by heating and partly moulded, and so can be used even where the skill and techniques needed for hard gemstone work are lacking. Amber is used in pieces from about AD 700. Brown glass was sometimes employed as a substitute for it. Mica occurs on the Moylough Belt-shrine.

Rock crystal is found on two Irish objects of the eighth century: on the underside of the Ardagh Chalice (Pl 6) and on the handle of the liturgical sieve from Derrynaflan. In both cases it is probable that the crystals were recycled from imported objects and not polished in Ireland. A crystal protected and displayed the relic of the true cross for which the Cross of Cong (Pl 20) was made in the 1120s. In later times large rock crystals feature prominently on objects in the Gothic style and as crude repairs to early objects such as the Shrine of St Patrick's Bell (Pl 19).

Although often called enamels, the *polychrome studs* that adorn objects such as the Ardagh Chalice and Derrynaflan Paten are really made of cast glass. They were cast in clay moulds, in two or three colours or with elaborate geometric patterns of grooves that were later inlaid in a contrasting colour. An example together with its clay mould was found at Lagore crannóg. Some high-quality studs have elegant silver grilles set into their

13

Photo 8 *Bell of cast
bronze from Cashel,
Co Tipperary, one of
a small number that
bear decoration in
the form of a wheeled
cross incised on the
main faces. Probably
ninth century AD.*

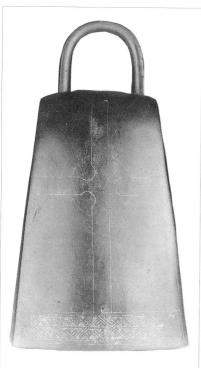

surfaces, and these clearly imitate the appearance of the metal bands of the cells that hold the garnet gemstones used in Frankish, Anglo-Saxon and other Germanic jewellery.

APPROACH TO DESIGN AND CONSTRUCTION

The metalworkers of early medieval Ireland favoured techniques that enabled them to produce large and complex objects by combining easily replicated components. The large bronze hand-bells of the ninth century and later, weighing up to about 6 kg (13.25 lb) (Photo 8), were the largest one-piece castings produced. Elaborate objects such as the Ardagh Chalice and Derrynaflan Paten were made from over three hundred parts. The replication of simple parts by casting made it possible to use components of the same pattern for many different objects.

An assembly code consisting of roman numerals was scratched on the back of some components of the Ardagh Chalice; the designer of the Derrynaflan Paten used letters and symbols as a guide for its assembly.

Patterns were tried out first in other media, and some scratched on stone or engraved on discarded food bones have survived. Hundreds of examples carrying patterns have been found on sites of the period *c.* 600–1200, and Dublin is particularly rich in them. Called 'motif pieces' or 'trial pieces', they may have been used for teaching, for trying out designs, for showing as samples to clients, or even as dies from which to take impressions in wax or foil. The ornament of the Donore discs was laid out by means of a compass-drawn grid, and the scrollwork was drawn partly mechanically and partly freehand.

Assembly was by riveting, soldering, wedging or nailing components together. Metal mounts were often nailed to their wooden supports: one of the Donore discs was secured by nails driven through holes in lugs on its

frame (Pl 1). Other craftworkers were less careful, and there are many examples of objects with nail-holes drilled through their decoration.

We know that at least one power tool was in use, because the surviving liturgical vessels were polished on a lathe. A hand press may have been used in some die-stamping. Compasses and dividers, punches, hammers, gravers, drills, anvils, stakes, tongs, shears, crucibles, furnaces and blow-pipes were all part of the smith's kit. Light and ventilation would have been necessary for many processes, and work was probably carried on outdoors in good weather.

Apart from the furnaces and mould fragments, workshops leave few traces. The specialised iron tools rust to become unrecognisable; scrap precious metal would have been carefully preserved for reuse.

RAW MATERIALS

It is unlikely that the Vikings were attracted to Irish monasteries by the bullion content of their shrines and sacred vessels. Precious metal seems not to have been common. The metalwork of the sixth and seventh centuries is

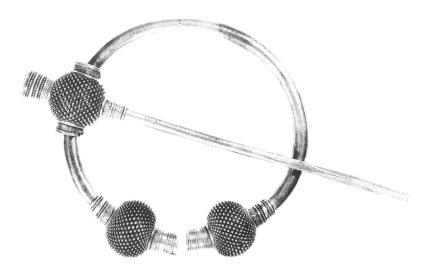

Photo 9 *Silver thistle brooch, Borris, Co Carlow, later ninth to tenth century AD. Variants of this type were popular throughout the Viking world.*

15

mainly of bronze, sometimes tinned to imitate silver. A few small silver artefacts were made about this time, perhaps with recycled Roman material. Silver, apparently often mixed with a high percentage of copper, was used for special commissions from the later seventh century to the ninth century.

Most of the great annular brooches, like the Tara Brooch, are of silver, as are most liturgical vessels that survive. (Some of the eighth-century Pictish brooches from St Ninian's Isle in the Shetlands have a silver content as low as 50 per cent. The silver of the Derrynaflan Chalice is about 70 per cent pure.) Gold was more rare, and objects of solid metal are exceptional. Stories in saints' lives about the miraculous provision of metal for enshrining relics make it clear that raw materials were scarce and that gold and silver were imported. While tin is available in small quantities in Ireland, it is more likely to have been an import also. Mercury, necessary for gilding, was imported either from Italy or southern Spain. Lead too may have come from the Continent. There is no evidence that the rich lead-silver deposits of Ireland were exploited before the thirteenth century. Native sources probably supplied copper and iron.

Viking trade in the ninth century made silver from the orient and gold much more abundant. From the late ninth to the late tenth century, large silver ornaments without polychrome decoration of gold or enamel became fashionable (Photos 9 and 16), and Irish kings received large quantities of silver coin and bullion in tribute, much of which was recycled.

THE HISTORY OF METALWORK STYLE, *c.* 450–1200

The Celtic La Tène style was established in Britain and Ireland during the prehistoric Iron Age and appears to have survived the Roman colonisation of Britain. There is controversy about the place and degree of survival of this art in the two islands, partly because the style that emerges in the early medieval period is strongly influenced by provincial Roman motifs. Of the commonest patterns that can be traced to the Iron Age tradition, two — the trumpet scroll (two divergent curves with a pointed oval forming the mouth) and the spiral with a bird-headed ending (frequently a crested-duck head) — are the most obvious (Photo 10).

16

cont. on p 25

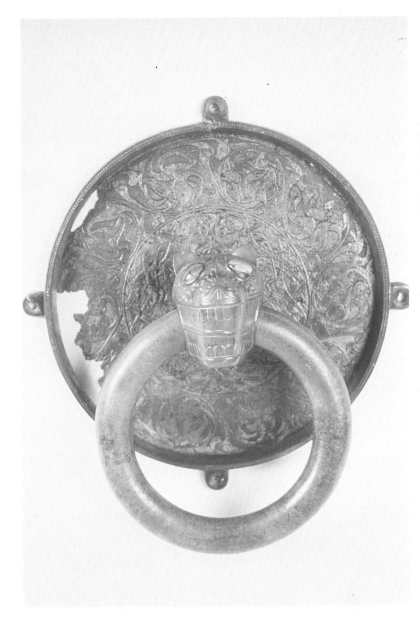

Pl 1 The handle assembly from Donore, Co Meath, earlier eighth century AD. The handle consists of three main parts: a frame and engraved tinned bronze disc, and a cast handle. The disc is 131 mm in diameter.

Pl 2 The belt-shrine from Moylough, Co Sligo, later eighth century AD. Found in a bog, it still contains the remains of a belt of an unknown saint. It is decorated with die-stamped silver foil, enamels, and millefiori.

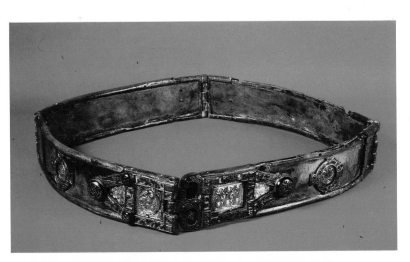

17

Pl 3 (a) The Irish house-shaped shrine of Abbadia San Salvatore, Tuscany, Italy. Preserved in the abbey of San Salvatore since at least the twelfth century, the shrine still contains the bones of an unknown saint. It is made of inlaid wood. (b) Detail of the shrine, showing the network of ornamental strips inlaid in grooves in the wood.

(a)

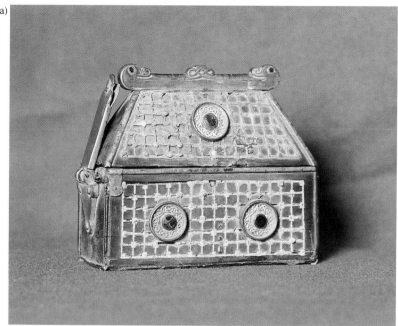

(b)

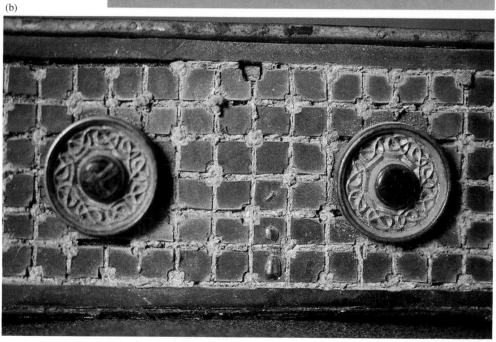

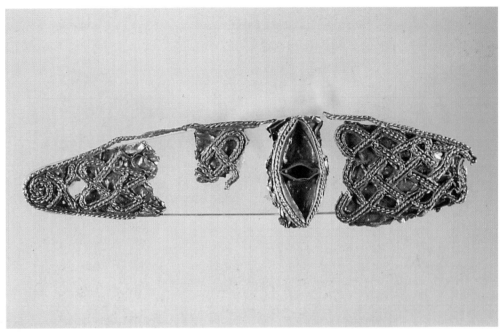

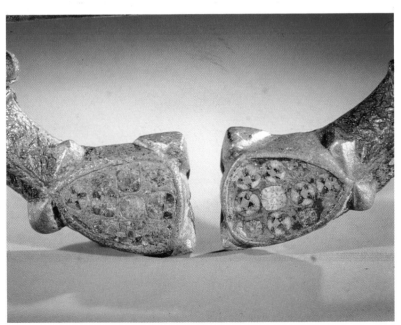

Pl 4 A fragment of gold filigree from Lagore Crannóg, Co Meath. Broken from a larger object, the filigree appears to be experimental in some respects. It dates from the seventh century AD.

Pl 5 The terminals of a penannular brooch from Ballinderry Crannóg, Co Offaly. Plates of millefiori are floated in a field of red enamel. Later sixth to earlier seventh century AD.

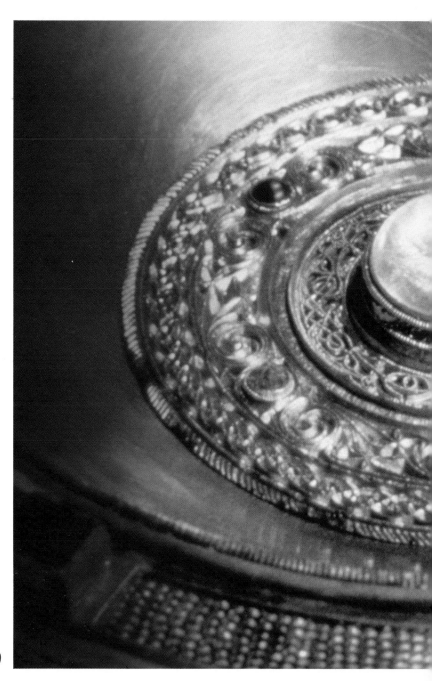

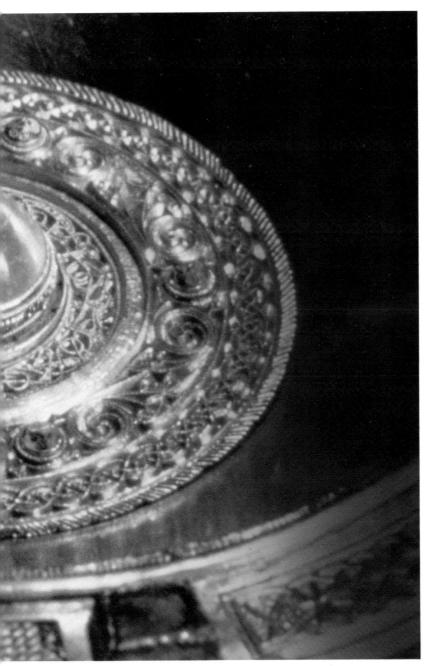

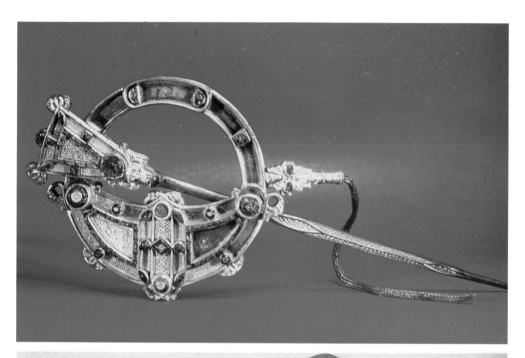

Pl 7 (Above) The Tara Brooch, front, later seventh to earlier eighth century AD. Made of cast silver-gilt, the brooch is decorated with cast ornament, gold filigree, amber, cast polychrome glass studs. Its animal ornament is close to the style of the Lindisfarne Gospels. This new type of brooch with a closed ring became popular in Ireland for about two centuries.

Pl 8 The Tara Brooch, reverse.

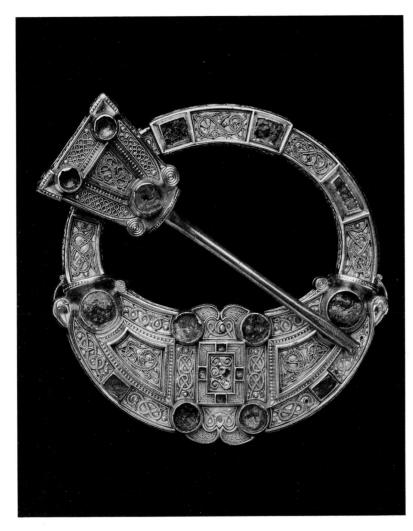

Pl 9 The Hunterston Brooch, Ayrshire, Scotland. A large brooch similar to the Tara Brooch. Later seventh to earlier eighth century AD.

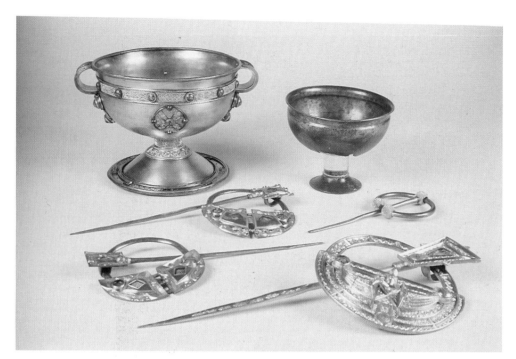

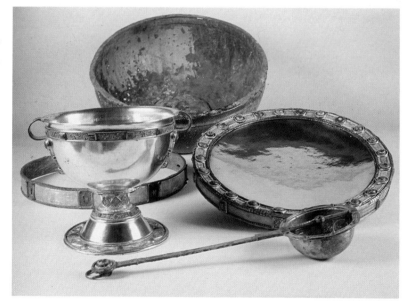

Pl 10 The hoard of church vessels and brooches from Ardagh, Co Limerick. Probably concealed in the Viking Age, the treasure contains brooches of various dates from the eighth to the tenth centuries AD. The silver chalice is one of the two finest examples of eighth-century work.

Pl 11 The hoard of church vessels from the monastery of Derrynaflan, Co Tipperary. Like the Ardagh hoard, it contains objects of various dates – the silver paten is eighth-century, while the chalice was probably made in the earlier ninth century. The date of concealment is unknown but it was probably during Viking times, perhaps the earlier tenth century.

cont. from p 16

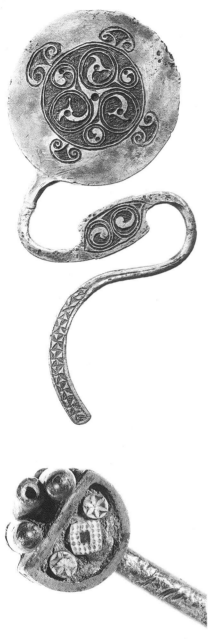

The earliest medieval style takes the form of engraved enamelled scrolls and later of 'reserved' scrollwork (where the surrounding metal is cut away so that the line of a spiral stands proud of the surface) seen against a background of champlevé red enamel. The commonest objects are cloak fasteners — the penannular or gapped-ring brooch with its terminals in the form of stylised animal heads (Pl 5) — and 'hand pins' (Photo 11). These were stick pins with heads in the form of a semicircular plate surmounted by a number of tubular beads resembling a hand with the fingers projecting at right angles. Both types can be traced to the Late Roman period, but they enjoyed their principal vogue in the fifth to seventh centuries.

The difficulty of tracing the history of art at this time is highlighted by a series of vessels fitted with suspension hooks known as 'hanging bowls'. These were often elaborately ornamented with appliqué enamelled plates called 'escutcheons'. Their ornament is similar to that on Irish penannular

Photo 10 *Bronze 'latchet' brooch, sixth to earlier seventh century AD. The central plate bears a spiral with crested bird-head endings reserved against a background keyed for red enamel, little of which survives.*

Photo 11 *Hand pin with millefiori glass.*

25

brooches and related objects. Most have been found in Anglo-Saxon graves in the south-east of England, and this, at first sight so surprising, can be explained by the fact that the Anglo-Saxons continued the pagan custom of placing objects in graves long after it had died out in Celtic Britain and Ireland.

Scholars argue about whether the vessels were imported or looted by the Anglo-Saxons, or whether they had been made in workshops in southern England now working for the conquerors. The only certain evidence for manufacturing such bowls comes from a site in Scotland, and the decorative affinities of the more elaborate ones lie in Ireland, so the balance of evidence suggests that the bowls were imported into England.

During the late sixth and seventh centuries we can detect a growing sophistication of ornament. The scrollwork becomes more complex, and florid and new colours of enamel are employed. In Ireland, millefiori appeared in the later sixth century, and some objects used it lavishly. Hanging bowls decorated in this style include one from the Anglo-Saxon princely ship-burial of Sutton Hoo, which was probably buried in the 620s.

The craftworkers of Ireland and Celtic Britain were in close touch throughout the sixth and seventh centuries and produced largely similar material. Irish work was mainly in bronze and enamel, and millefiori was popular. In Scotland, silver was more common and millefiori does not appear. The evidence from Wales is small, but the site of Dinas Powys yielded slight evidence of millefiori working. It is misleading to assume that millefiori was confined to the Celtic lands at this time: Anglo-Saxon jewellery from Sutton Hoo bears examples custom-made for their settings.

The Golden Age (later seventh to mid-ninth centuries)

Contacts with the Anglo-Saxons in the seventh century led to significant changes in the arts of the Celtic lands. The activities of Irish missionaries in Scotland and northern England and the campaigns of conquest by the kings of Northumbria in southern Scotland ensured continuing interaction among the Picts, Angles, and Irish colonists. Through these contacts the Irish metalworker gained access to many new techniques: gilding, filigree, casting to simulate faceted engraving, the adoption and transformation of

Germanic-style animal art, and the imitation of a whole new range of types and visual effects.

The links of the Irish missionary church with Europe are often overlooked when the formation of this new hybrid art is discussed. At least one major piece of the later eighth century, the Moylough Belt-shrine (Pl 2), owes a debt to Frankish models. Ireland has so far produced very few imported objects that might help to document the emergence of the new style: our evidence consists of reflections of foreign styles already transformed when we encounter them on native objects. It was above all a polychrome style, dominated by animal ornament, and although it is often thought of as purely decorative and abstract, by the end of the seventh century it had already successfully absorbed Christian symbolism.

The development of the style is usually traced in manuscript illumination in the seventh and earlier eighth centuries. This is inspired by the view that these are closely dated and reasonably well provenanced. They are not. Of the major manuscripts in the insular style, the only examples that can be clearly dated to within two or three decades or so belong to the ninth century or later. The dating of the earlier ones, including the very greatest, is either inferential or based on the acceptance of non-contemporary evidence.

There is no doubt that the Columban missions to northern Britain played a major part in the genesis of the high style of illumination. Most would regard the Book of Durrow (later seventh century) as the earliest of the great Gospel books that survive. It was painted either in Ireland, where there is a solid artistic context for it, or in a monastery of strong Irish orientation in north Britain, perhaps Iona, the headquarters of the Columban family of monasteries. Most of the ornament is of trumpet scrolls, spirals and lentoids derived from metalworking traditions. Interlace, an innovation, is used for the first time, as are dot-outlining and, above all, one page of animal ornament based on Anglo-Saxon models. Durrow is the earliest good evidence we have of the blending of traditions in a new style and of the significant translation of metalworkers' effects into a new idiom.

The maturity of the new art is achieved in manuscripts with the Book of Lindisfarne, painted at the monastery of that name in Northumbria, and in metalwork with the Tara Brooch, both produced towards the close of the

seventh or the beginning of the eighth century.

The ornament of Lindisfarne is superb. Trumpet scrollwork, often with zoomorphic or animal elements, spirals, animal interlace, contorted beasts with credible anatomical detail and skilfully drawn stylised birds provide the ornamental repertoire. The animal is often a long-bodied quadruped shown in profile with the torso turned through hind legs, which are spread compass-like. Portraits of the evangelists show the influence of Italy, which was so strong in Northumbria at the time, but the ornament has clear links to Irish metalwork.

The Tara Brooch (actually found near Bettystown, Co Meath) (Photo 12; Pls 7, 8) is the most lavish of a new type of ornament, the annular brooch devised not to fasten a cloak but to display fine ornament. It is made of cast silver in the form of a complete ring, about half of which is expanded for the display of ornament. It is fitted with an elaborate free-swivelling pin with a decorated head. Its ornament is laid out in panels that recall the form of penannular brooches, but its lavish filigree ornament, glass and amber and birds' heads and beasts projecting from its margins recall features of Germanic brooches. Its ornament of animals, bird processions and trumpet scrolls with abstract zoomorphic elements strongly resembles the paintings of Lindisfarne.

The Tara Brooch has a close analogue in the Hunterston Brooch from Ayrshire in Scotland (Pl 9). Another close comparison is the ornament of the hoard of door or shrine furniture found recently at Donore near Kells, Co Meath (Pl 1; Photo 13). Here too the Tara-Lindisfarne repertoire is reproduced in cast *kerbschnitt* and on a lightly engraved tinned bronze disc in an effect very close to painting. The stylised composite lion-head ring-handle seems to represent an attempt by the metalworker to adapt classical models to native taste and technology. The objects probably belonged to a church.

Hoarding in Viking times has preserved a great deal of metalwork from eighth- and ninth-century Ireland. The greatest of these are the finds of altar vessels and brooches from Ardagh, Co Limerick (Pl 10), and the liturgical vessels from Derrynaflan, Co Tipperary (Pl 11). The large two-handled chalice from Ardagh and the great paten from Derrynaflan take the polychrome style to its height. Cast-glass studs in imitation of cloisonné

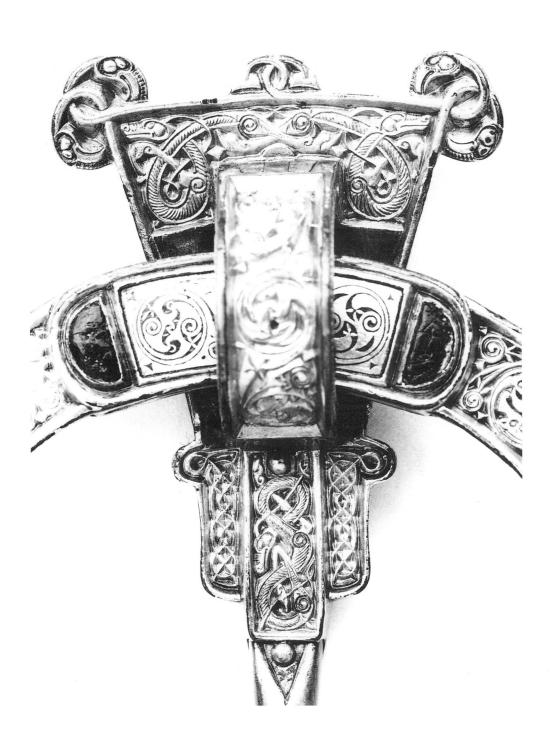

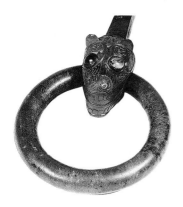

Photo 13 *Cast bronze door-handle from Donore, Moynalty, Co Meath. Earlier eighth century AD.*

gemstones, filigree animal interlace of remarkable refinement, cast ornament, engraving, stamped foils and knitted wire mesh are combined to produce pieces of great beauty (Photos 5, 14; Pls 12, 13, 14). Both belong to the later eighth century, and on close examination much of their ornament shows strong parallels with Anglo-Saxon work of that time, though rendered in a distinctive Irish manner. But despite the insular style of ornament they are firmly based on late Roman models, which provide the only satisfactory ancestry for their friezes of beast-ornament. The animal ornament of the paten was richly symbolic, and we may suspect the same of the Ardagh Chalice.

The ninth-century chalice from Derrynaflan (Pls 15, 16) is an ambitious composition, which demonstrates that the high style of ornament survived the initial impact of the Viking raids. Its filigree ornaments seem disjointed, but close study shows that they are vigorous and well drawn and are modelled on common Christian symbolic themes. There is no enamel on the chalice, and this accords with the decline in polychromy that is noticeable in the ninth and tenth centuries.

Many reliquaries made in both Ireland and Scotland survive from the period. A book-shrine from Lough Kinale, Co Longford (Photo 15), shows that the Irish practice of enshrining revered books had begun by the eighth century.

Much more widespread is the house-shaped or tomb-shaped shrine, of which complete and fragmentary examples have been found in Ireland and related examples in Scotland as well as in France, Italy, and Scandinavia, where they were taken by the Vikings. They are small portable caskets, often of wood sheeted or inlaid in metal, that mimic the appearance of hip-roofed buildings, perhaps churches or tombs (Photo 3). They are a variant form of a shrine type common in early medieval Europe. All the known examples have applied medallions and elaborate ridge-poles, sometimes with beast-heads.

Two examples — one in Abbadia San Salvatore in Tuscany (Pl 3), the other from Norway and now in Copenhagen — contain corporeal relics, which may be original. Recently a magnificent and nearly complete small

30

(a)

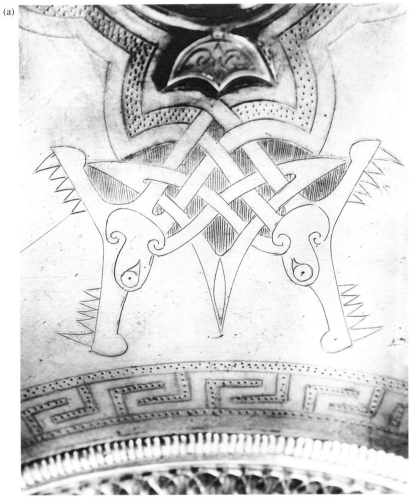

Photo 14 (a) *Engraved ornament on the surface of the bowl of the Ardagh Chalice.* (b) *Cast ornament on the base of the stem of the Ardagh Chalice.*

(b)

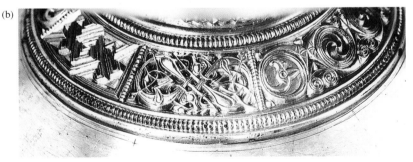

31

example with seventh-century scrollwork decoration was found at Clonmore, Co Armagh, while an almost exact analogue, buried for centuries in a tomb in St Columbanus's monastery of Bobbio in Italy, has come to light. Both are made of engraved tinned bronze plates, and both show how early the Irish version of the house-shaped shrine emerged. The finials of a very large

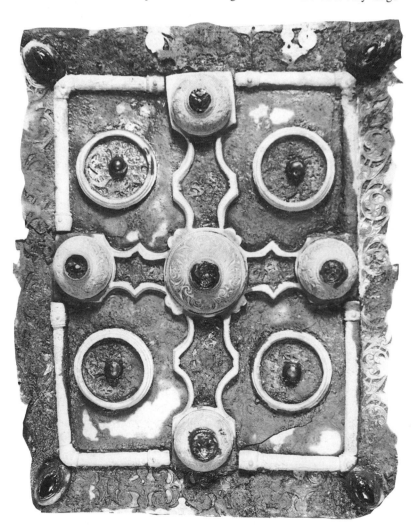

Photo 15 *The Lough Kinale book shrine. Recently found in a dismantled state on the bottom of a lake in Co Longford, it was made probably in the eighth century.*

cont. on p 41

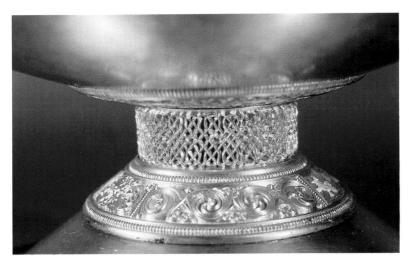

Pl 12 The Ardagh Chalice, detail of the stem.

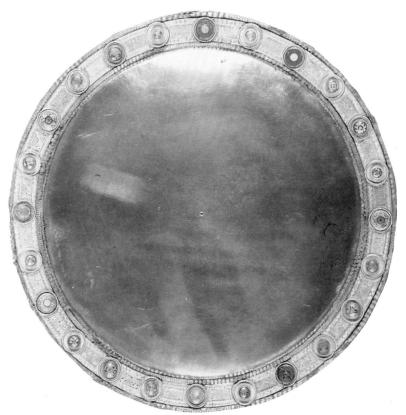

Pl 13 The Derrynaflan Paten, eighth century AD.

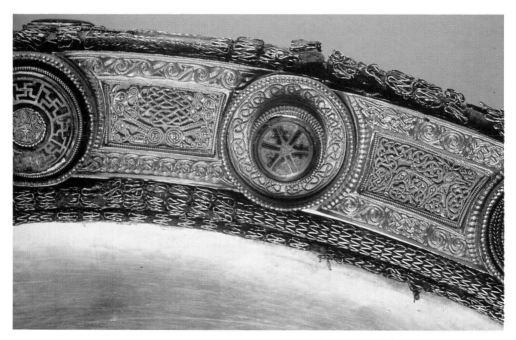

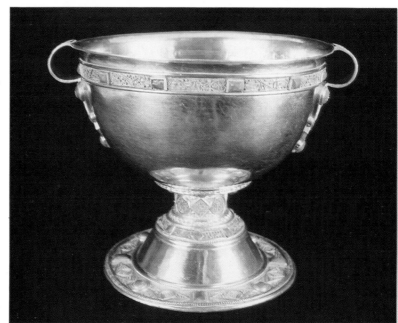

Pl 14 The Derrynaflan Paten, detail of the filigree and knitted wire mesh rim. The tiny gold panel on the right depicts a stag in an interlace of snakes.

Pl 15 The Derrynaflan Chalice, ninth century AD. The ornament consists of filigree and amber.

34

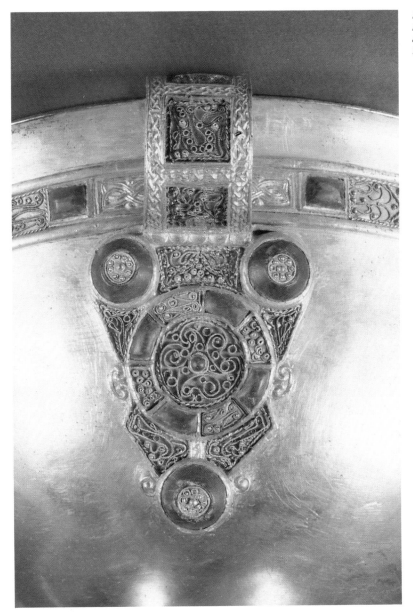

Pl 16 The Derrynaflan Chalice: detail of handle and its escutcheon plate.

*Pl 17 Enamelled
metal and wood cross
from Co Antrim, later
eighth to earlier
ninth centuries AD.*

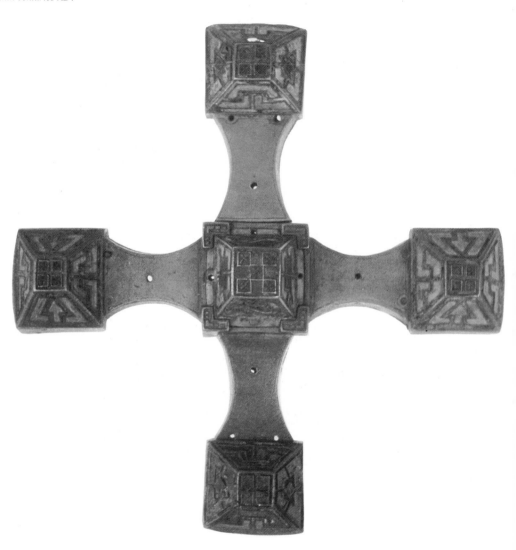

36

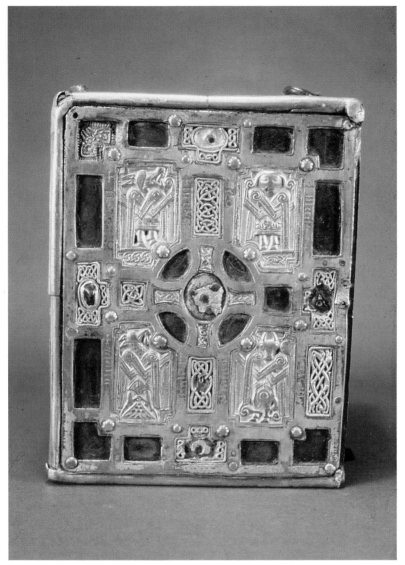

Pl 18 The Soiscéal Molaise, a book shrine made for the monastery of Devenish, Co Fermanagh, in the first quarter of the eleventh century. The front shows the symbols of the evangelists.

Pl 19 The Shrine of St Patrick's Bell, c. AD 1100. The ornament of gilt bronze openwork plates is one of the most elegant Irish expressions of the Scandinavian Urnes style.

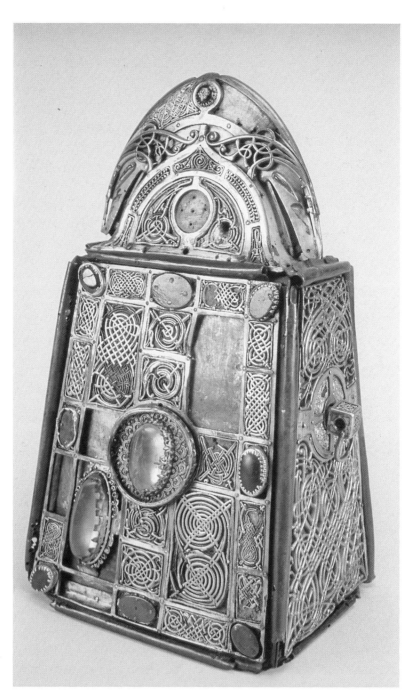

38

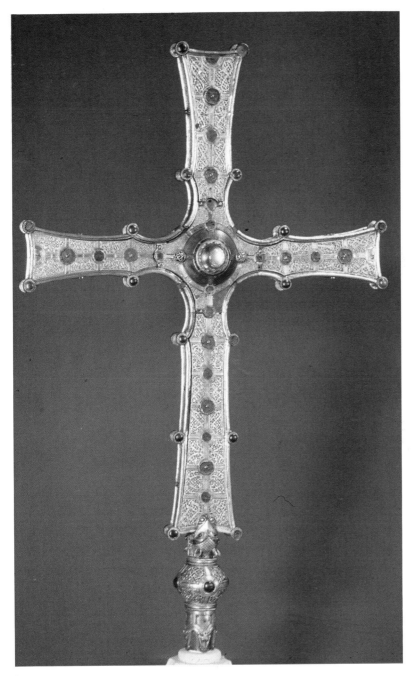

Pl 20 The Cross of Cong. Made about AD 1120 to enshrine a relic of the true cross, it is the latest in a tradition of wood and metal crosses stretching back to the eighth century. It is probably the most elegant and accomplished object of the revival of Irish art in the eleventh and twelfth centuries.

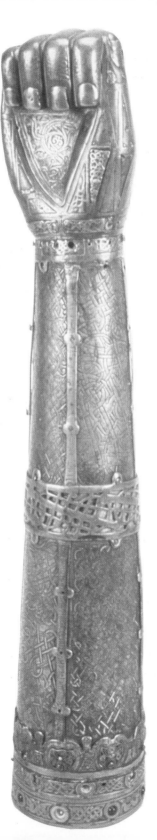

40

cont. from p 32

example are preserved in the museum of Saint-Germain, near Paris, and almost exact analogues, perhaps from the same shrine, were found at Gausel in Norway. Shrines with finials of that size may have been sarcophagi, but most were made to be portable and were fitted with carrying straps. The backs of the shrines, where they would have rubbed against the breast of the person carrying them, are, significantly, plainer than their fronts. Historical sources mention the *commotatio* or taking of saints' relics on circuit, especially in times of distress.

The cult of relics was highly developed in Ireland, and other important reliquaries survive intact: the Moylough Belt-shrine, made to enclose the girdle of an unknown saint in the eighth century, combines champlevé enamel, millefiori and die-stamped silver to beautiful effect. Its background seems to lie in ornamental belt fittings fashionable among the Franks in the early seventh century (Pl 2). Other church objects included crosses, of which a complete small example with enamelled ornament is preserved in the Hunt Museum, Limerick (Pl 17).

The Vikings

The Vikings first appeared in Ireland at the end of the eighth century and by the middle of the ninth century had begun to form coastal settlements such as Dublin, Waterford, Cork, and Limerick. The conventional belief is that the effect of the Vikings on Irish art was devastating, but this is exaggerated. True, both in Ireland and among the Picts precious objects were sometimes buried for safe-keeping. It is also true that Viking graves in Norway and elsewhere contain a range of Irish and related objects, both broken up and reused and complete, and that some of these were religious. Irish annals speak of the devastating effects of the Vikings, and fashionable revisionism of modern times should not blind us to the terrible and shocking effect they had on contemporaries (Photo 17).

Nevertheless, metalworking continued in Ireland, and some of the greatest artistic achievements in all media belong to the late eighth and early ninth centuries. In manuscript painting the ambitious Book of Mac Regol and the elegant Book of Armagh, notable for its accomplished pen-and-ink drawings, were produced in the early ninth century. A local school of manuscript

Pl 21 (Facing page) The shrine of St Lachtín's Arm, early twelfth century. The arm was covered in a network of animal interlace in silver-and-niello inlay. It is 390 mm high. The ornament of the palm shows Romanesque influence.

41

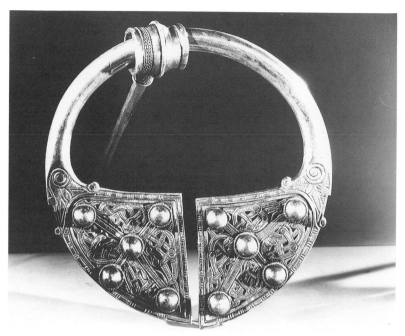

Photo 16 *The Ballyspellan silver penannular brooch, Co Kilkenny. Found in a hoard with two others now lost, the Ballyspellan Brooch is the finest of a series of hybrid silver cloak fastenings that appeared during the Viking Age in Ireland. It was made of hammered silver, probably during the first half of the tenth century AD. A series of personal names is scratched on the back of the ornament in ogham characters.*

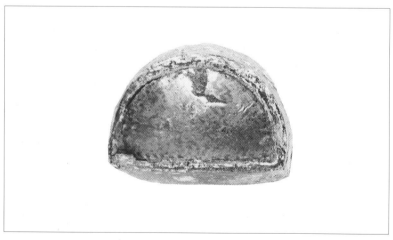

42 Photo 17 *Lead weight from the Viking Age cemetery of Islandbridge, Co Dublin. The ninth-century cemetery of Dublin yielded a number of fragments of Irish metalwork mounted on lead to use as weights.*

production in the style of the latter was still in being in Armagh three hundred years later.

The same period also saw the flowering of stone sculpture, an art that, no less than fine metalwork, requires wealth and security. Some of the high crosses, such as the later ninth-century crosses of Ahenny, Co Tipperary, owe a clear debt to the metalworker.

Early borrowings from Viking styles are difficult to detect. The eastern trade of the Scandinavians introduced large quantities of silver, and this prompted the emergence of brooches that abandoned the colourful effects of enamel and gilding (Photos 8, 9, 16). Their styles did not become really influential until the eleventh century, by which time the Vikings' political and military power had declined. Many Scandinavian traits in Irish art may have been mediated through Danish England, with which the coastal towns founded by the Vikings had close links, but the workshops of Dublin were themselves sources of innovation in the Viking world from the early eleventh century.

In the eleventh century a series of important reliquaries were either repaired or created. One, the Soiscéal Molaise (St Molaise's Gospel), a book-shrine, was covered with decorative plates no later than about 1025 (Pl 18). Some of these bear motifs of Viking inspiration, but the main ornament has a strong native flavour, and the symbols of the evangelists on the front hark back to native manuscript painting. A shrine for the seventh-century manuscript, the Cathach of St Colm Cille, was made in the later eleventh century at Kells, and its original decoration embodies elements of the Scandinavian Ringerike style. An ambitious bishop's staff, the Innisfallen Crosier (Photo 19), was made about the same time or a little earlier and bears fine filigree in a style matched on a recently discovered 'kite brooch' from

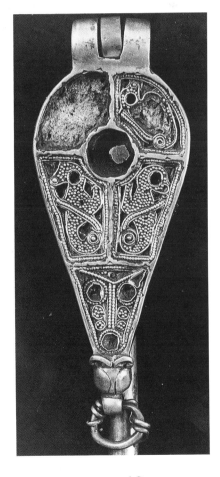

Photo 18 *Silver kite-shaped brooch, find place uncertain. One of a series of cloak ornaments associated particularly with Viking Age towns, this example bears animal ornament with granulation infill. Probably later tenth or earlier eleventh century AD.*

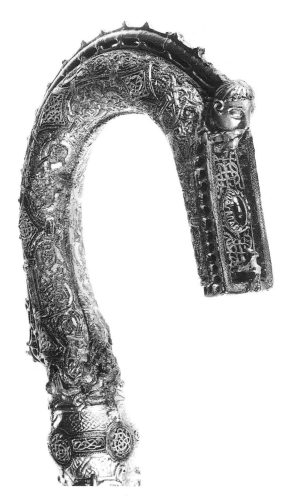

Photo 19 *The Innisfallen Crosier, mid to later eleventh century AD. Found in the River Laune, Killarney, Co Kerry, the crosier is made of silver and bronze, which is now badly oxidised and brittle. It carries cast animal ornament of Scandinavian inspiration on the crook and elegant gold filigree in a style that is somewhat different from Irish fashions of the eighth and ninth centuries.*

eleventh-century deposits at Waterford. The crosier from Clonmacnoise (*c.* 1100) has exceptionally fine silver-and-niello animal ornament on its crook (Photo 7).

The Scandinavian Urnes style, already out of fashion in the homeland, enjoyed a vogue in twelfth-century Ireland, where it was combined with Romanesque influences. The Shrine of St Patrick's Bell, made about 1100, is one of its most elegant expressions (Pl 19). The finest is the Cross of Cong, made about 1123 to enshrine a relic of the true cross, probably at Roscommon (Pl 20). The large reliquary of St Manchán's Shrine, still preserved at Boher, Co Offaly, is in the same decorative tradition. An arm-shaped reliquary in the continental tradition, the Shrine of St Lachtín's Arm, was made early in the twelfth century under royal patronage in Munster (Pl 21). An Irish horn-reliquary that has traits in common with it found its way to Tongeren in Belgium some time in the later Middle Ages. The Lismore Crosier, made before 1118, deploys not only sophisticated Urnes-style ornament but also motifs that hark back to the art of the eighth and ninth centuries (Photo 20*a*, *b*).

These objects in a way mark a return to the style of earlier times. The reform of the church, the surmounting of the Viking threat and the patronage of kings all contributed to this partly new, partly revived art. The arrival of

44

regular monastic orders from the Continent, the decline of the great native monasteries and finally the Anglo-Norman invasion of 1169 meant the gradual loss of patrons for native artists, and the tradition dwindled away. There were to be a few fitful attempts at revival in the later Middle Ages, but these were mainly concerned with the repair of more ancient shrines, and by the sixteenth century all continuity with native craftsmanship had been broken.

(a)

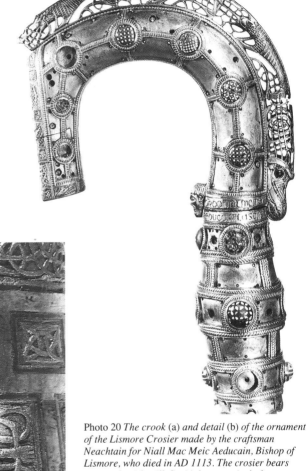

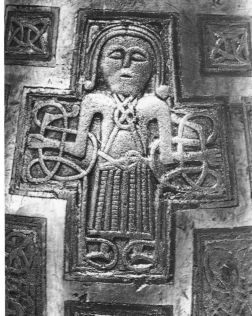

(b)

Photo 20 *The crook* (a) *and detail* (b) *of the ornament of the Lismore Crosier made by the craftsman Neachtain for Niall Mac Meic Aeducain, Bishop of Lismore, who died in AD 1113. The crosier bears cast studs with millefiori inlay, a revival of past glories. The decorative panels of the crook have been stripped of their ornaments, presumably of precious metal.*

45

GLOSSARY

crannóg: from the Irish *crann*, a tree; a dwelling on an artificial or artificially enlarged island.

enamel: a vitreous or glassy material applied in powdered form to a metal surface and then fixed in place by being fused by means of heat. Colours are produced by adding metal oxides.

escutcheon: a term derived from heraldry, used to denote a decorative applied plate. On hanging bowls, normally the plate from which the suspension hooks spring.

filigree: ornaments formed of soldered wires, usually of gold or silver.

kerbschnitt: originally a term applied to traditional German wood-carving in which patterns are cut with deep, sloping cuts of the chisel. An effect resembling this was produced in ancient metalwork, which was often, particularly in Ireland, mimicked by means of casting.

lathe: a tool designed to spin wood or metal so that it can be carved (wood) into circular shapes or pressed into shape or polished. The lathe in early Ireland was probably muscle-powered, using a cord or belt to turn a spindle. This would have been attached to a flexible overhead beam that was caused to spring up and down by means of a treadle.

millefiori: in early medieval Ireland a type of ornament made of bundles of coloured glass straws fused together by heat so that a pattern shows when viewed in cross-section. Millefiori rods were cut up into platelets, which were then sunk in the enamel fields of ornaments or mounted directly on decorative metalwork.

niello: a black compound of silver or copper sulphides fused to a metal base at low temperature.

penannular: an incomplete ring. Used especially of early medieval ring brooches in which there is a gap in the ring to enable a free-swivelling pin to pass through.

repoussé: motifs produced in relief by hammering from the back.

Ringerike style: a Scandinavian art style named after a district north of Oslo that flourished in the homeland especially in the first half of the eleventh century. In addition to stylised lion and snake motifs derived from earlier Viking sources, it employs vegetal elements in its design. In Ireland a distinctive version of the style remained in use into the twelfth century, and there is growing evidence that the workshops of Dublin made a significant contribution to the emergence of the style.

Urnes style: named after a wooden church in Sogn, Norway, which bears striking carved decoration, it is an elegant style characterised by a slender quadruped in combat with a snake. The beasts normally have a distinctive pointed oval eye. A version of the style combined with Romanesque and native elements emerged in Ireland by the end of the eleventh century and remained in fashion until the mid-twelfth century at least.

SELECT BIBLIOGRAPHY

Henry, F, *Irish Art in the Early Christian Period to AD 800*, London, 1965.
 Irish Art during the Viking Invasions, 800–1020 AD, London, 1967.
 Irish Art in the Romanesque Period, 1020–1170 AD, London, 1970.

Ryan, M (ed), *Treasures of Ireland*, Dublin, 1983.
 Early Irish Communion Vessels: Church Treasures of the Golden Age, Dublin, 1985.
 (ed), *Ireland and Insular Art, AD 500–1200*, Dublin, 1987.

Youngs, S (ed), *The Work of Angels: Masterpieces of Celtic Metalwork, 6th to 9th Centuries*, London, 1989.